Vignettes
Vignettes Vignettes V
Vignettes Vignette
ignettes Vignettes V
Vignettes Vignette
ignettes Vignettes V
Vignettes Vignette
ignettes Vignettes V
Vignettes Vignette
ignettes Vignettes V
Vignettes Vignette

MAXFIELD PARRISH

THE BOOK ILLUSTRATIONS

Michael J. Goldberg

Collectors Press, Inc.
Portland, Oregon

Acknowledgements

Collection courtesy of Erwin Flacks, Fine Art
Marketing Co., and the archives of Collectors Press, Inc.

Editor:
Michael J. Goldberg

Design:
Hoover H.Y. Li

Published by: Collectors Press, Inc.
P.O. Box 230986, Portland, OR 97281
1-800-423-1848

Printed in Singapore

First American Edition

10 9 8 7 6 5 4 3 2 1

ISBN: 1-888054-21-2

Maxfield Parrish

"And what is the use of a book"
thought Alice, "without pictures."

Alice's Adventures in Wonderland, Lewis
Carroll

Indeed, as Alice remarked, viewing
her older sister's book before embarking
on her adventures in Wonderland, books
need pictures – especially those directed
toward children. When Alice made her
classic observation, not many adults were
making books for children. Early Victorian
children likely read books heavy with
morals and sponsored by the Church of
England. Critics have called *Alice's
Adventures in Wonderland* a parody and polit-
ical critique. In reality, it was written as a

child's story. It was the first children's fantasy book to become widely popular.

Carroll's *Alice* appeared at the dawn of a technological revolution. With advances in printing processes allowing color reproduction, book publishing became a thriving industry. Nowhere did creative expression flourish as fully as in fantasy illustration. In areas such as poetry, classics,

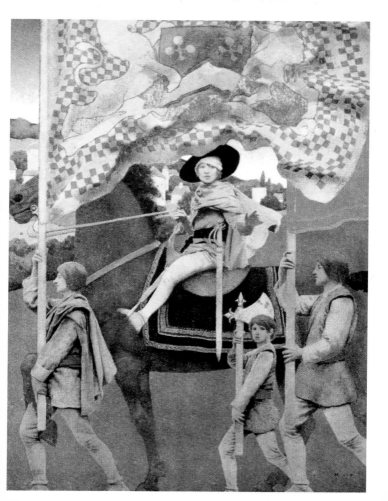

and children's books, creative artists found blank canvases on which to express their inner visions. The huge buying public eagerly purchased this commodity – available to many for the first time.

The demand for illustrators literally created a new field of employment. Many of the Victorian era children's illustrators rose to prominence – Sir John Tenniel, whose illustrations for

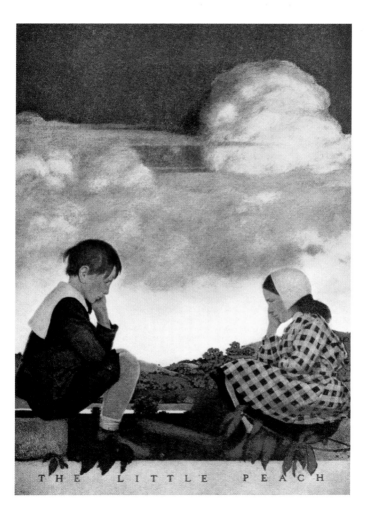

THE LITTLE PEACH

The Fisherman and the Genie
The Arabian Nights
1909

the original *Alice's Adventures in Wonderland*, have become classics; Randolph Caldecott, for whom the Caldecott Award for children's illustration is named; Kate Greenaway, who created her own world with her familiar children's drawings; Walter Crane, whose "Toy Books" series first appeared in 1865 – these were some of the earliest. By the turn of the century,

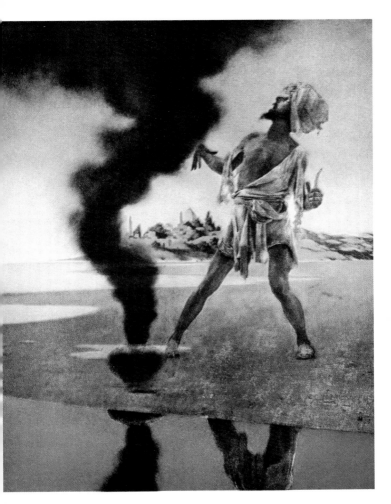

The Reluctant Dragon
Dream Days
1898

England was producing fantasy illustrators like Arthur Rackham, Edmund Dulac, and Aubrey Beardsley.

During this time, America still looked toward England for styles and trends. The incredible amount of illustrated art coming out of Great Britain could not be denied. Into this period Maxfield Parrish was born. Surely many books that Parrish read as a child were published in England.

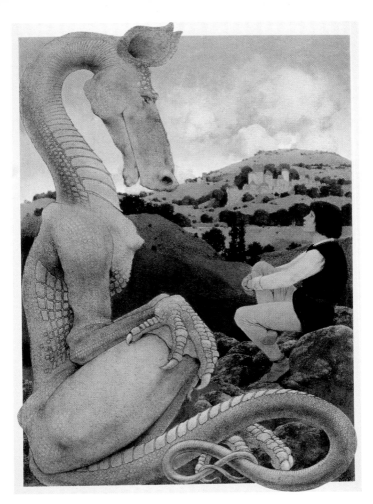

Cassim
The Arabian Nights
1909

Children's books printed in America were still somewhat crude, though readily available and inexpensive. By the time Parrish was making great strides in his career as an illustrator, he would also be making great contributions to children's book illustration in its Golden Age.

Parrish contributed his early black-and-white artwork to such books as *Mother Goose in Prose, Dream Days,*

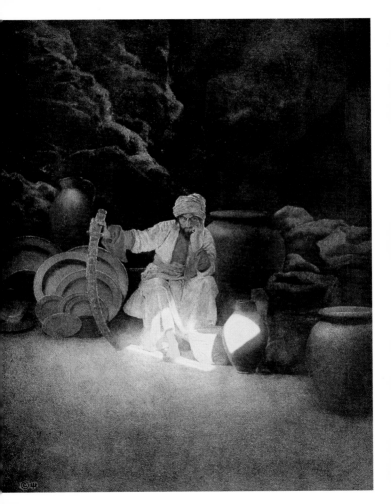

and *The Golden Age*. The character of
Mother Goose and the vision of the
world as seen by a child was perfectly
captured by Parrish's illustrations.
When Parrish moved into his color-
illustration period, his style blossomed.
His book career culminated in *The
Knave of Hearts*. These illustrations cap-
tured the essence of the Parrish style.

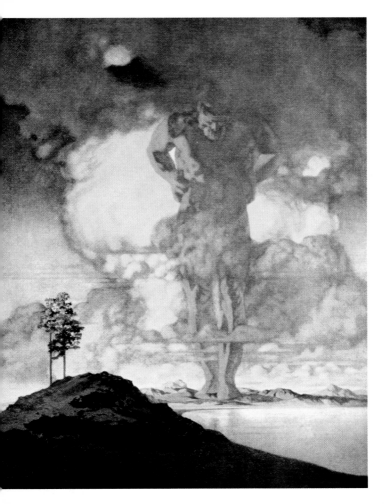

Jason and the Talking Oak
A Wonder Book and Tanglewood Tales
1910

Parrish's career in book illustration began on a positive note. His first illustrated book was *Mother Goose in Prose* published in 1897 by Way and Williams. The author was none other than L. Frank Baum, who achieved fame a few years later as the creator of the Wizard of Oz. *Mother Goose in Prose* was a collection of whimsical prose stories based on nursery rhymes. Parrish contributed a full-color cover

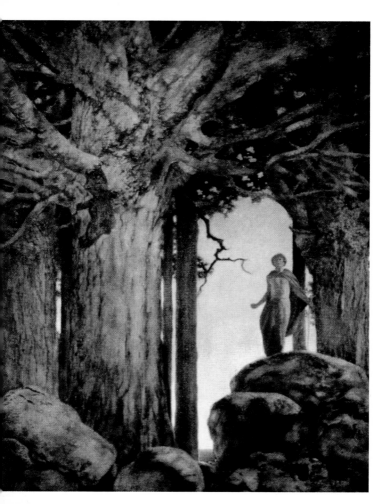

Its Walls Were as of Jasper
Dream Days
1898

and fourteen black-and-white illustrations. The combination of author and illustrator produced a book that became a huge success, with several printings in later years. The black-and-white illustrations make strong use of texture and design to produce wonderful images. Many Mother Goose characters dear to Parrish are featured here: Old King Cole, Little

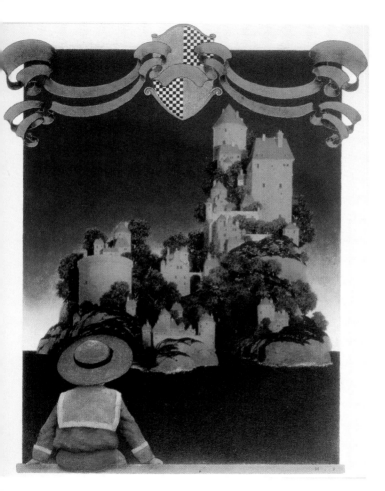

Bo-Peep, The Man in the Moon, and Humpty Dumpty, whose broad smile has become a familiar image.

After the success of *Mother Goose in Prose*, Parrish's major book commissions came annually for the next few years. He literally started the next assignment as he neared the end of the previous book. He dovetailed the book commissions into his schedule of advertising and magazine assignments.

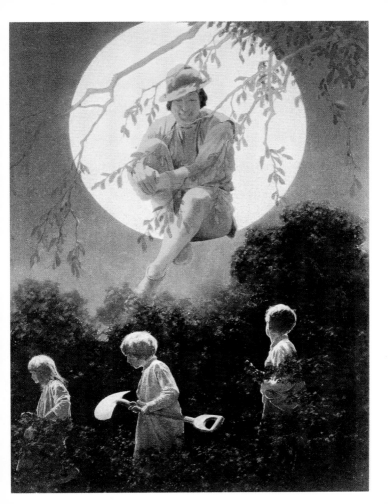

With Trumpet and Drum
Poems of Childhood

1904

Parrish was proficient in creating on a
tight schedule, and, in 1900,
Knickerbocker's History of New York by
Washington Irving was released with
Parrish illustrations. A whimsical par-
ody of old New York written one hun-
dred years earlier, Parrish's illustra-
tions were perfectly suited for the
book because of his personal depiction
of the characters.

Parrish's next two book commissions were *The Golden Age* and its sequel *Dream Days*, both by Kenneth Grahame. These two books featured the world viewed through a child's mind and imagination. Both explore childlike fantasies of dragons and castles, mysterious gardens, wandering roads, and adults who appear as gods of mythology. Parrish's pictures of

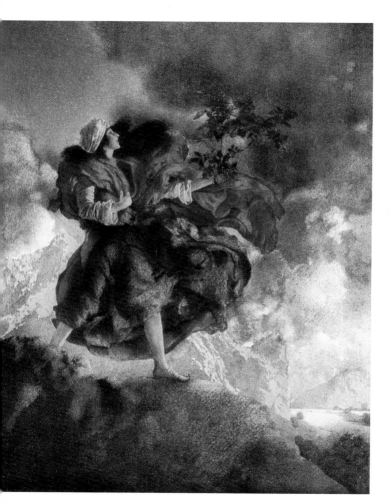

The Cardinal Archbishop
The Turquoise Cup and the Desert
1903

children set among their imaginings
are neither coy nor idealized. Like
Dorothy, who casually strolled
through Oz, the children of Parrish's
work seem believable as they move
through their fantasies. *The Golden Age*
was the first of Parrish's books to
become popular in Europe. The British
in particular, who had spearheaded the
book illustration movement, were
taken by the Parrish style when *The*

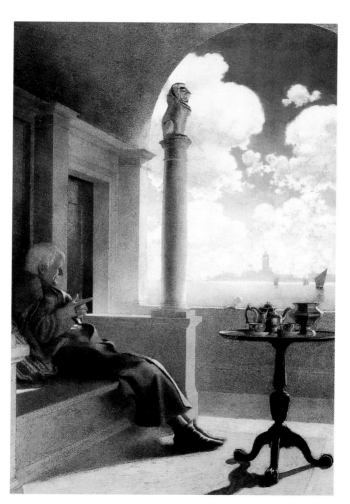

The Reservoir
Italian Villas and Their Gardens
1904

Golden Age was published in London simultaneously with its release in America. This overseas recognition expanded Parrish's devoted audience beyond its American boundaries.

The next book Parrish illustrated was a milestone in his book illustration career. *Poems of Childhood*, by noted American poet Eugene Field, was Parrish's first full-color book and became the children's book for which

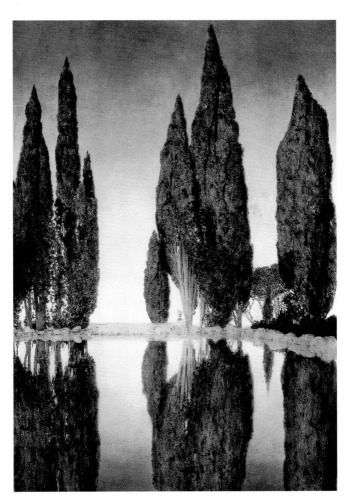

he is most remembered. Originally
appearing in the *Ladies' Home Journal*,
the idea was quickly expanded by the
publisher into book form published in
fall 1904. Parrish provided eight full-
page illustrations, as well as the cover
and miscellaneous pieces of art. Field's
poems, particularly "Wynken, Blynken
and Nod" and "The Sugar-Plum Tree,"
were already children's favorites and
Parrish's illustrations still appear in

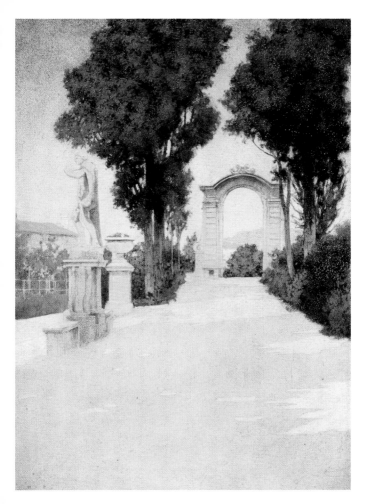

poetry anthologies. Parrish again
used his personal vision, inspired by
the poems, to illustrate the works,
delivering stunning pieces rife with his
dreamlike quality. Most notable is the
illustration called *The Dinkey-Bird*. In
it, a maiden on a swing sails past
billowing clouds and a castle-crowned
mountain top. *The Dinkey-Bird* pulls

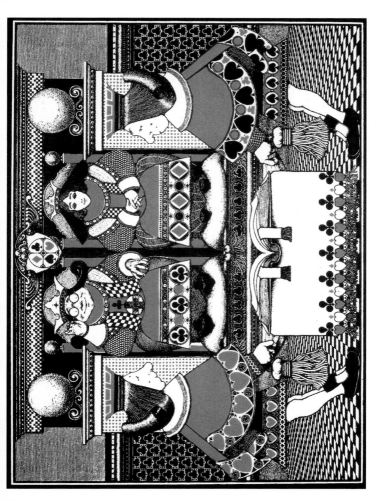

The Argonauts in Quest of the Golden Fleece
A Wonder Book and Tanglewood Tales

1910

together a Parrish theme that re-appeared
time and time again, without swing.

Further Parrish book commissions
continued, grown from illustration jobs
originally created for magazines.
Parrish's next book project began as
one such magazine assignment. This
book was to be a departure in subject
matter from his usual images of fancy.
First serialized in the *Century Magazine*,

Bellerophon by the Fountain of Pirene
A Wonder Book and Tanglewood Tales
1910

Italian Villas and Their Gardens appeared in 1904 in book form. Written by noted American novelist Edith Wharton, the volume was a collaboration based on the author's and illustrator's research in Italy (although they did not travel together). The result was an interesting book that pleased the author and gave Parrish a chance to break from his usual works and

concentrate on detailed architectural
renderings. The numerous illustrations
for this book are more than renderings
of buildings. Parrish incorporates
landscape elements with his Parrish-
blue skies to produce some beautifully
evocative paintings. Not as widely
known as his children's books, *Italian
Villas* is no less intriguing in the
Parrish pantheon.

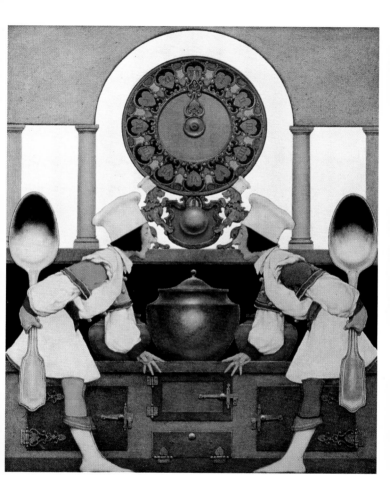

Parrish's next two books wan-
dered into the realm of the mythologi-
cal and both originated as magazine
illustrations. *The Arabian Nights* first
appeared in *Collier's* magazine and in
book form in 1909. Besides depicting
popular tales such as "Aladdin," "Ali
Baba," and "Sinbad," Parrish illumi-
nated lesser known tales with beautiful
illustrations. *Prince Agib, Search for the*

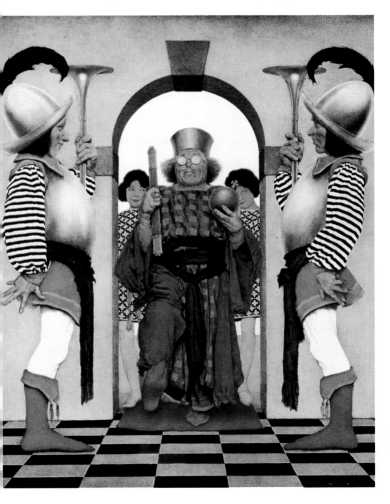

Singing Tree, and *The King of the Black Isles* have become recognizable classics from this book.

The following year, the release of *A Wonder Book and Tanglewood Tales* brought to book form the illustrations Parrish had done for *Collier's* under the name *Greek Mythology*. Nathaniel Hawthorne's books, first published in the 1850s, were a series of Greek

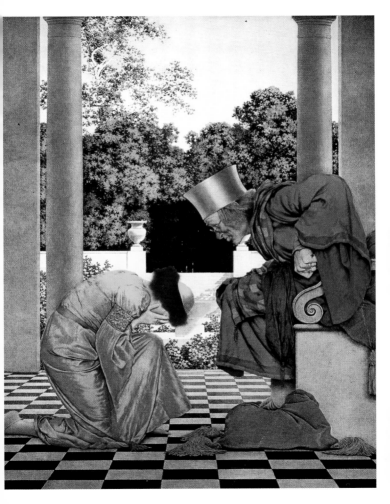

myths retold for children. Parrish's
paintings for the book are not only
remarkable illustrations, but intense
visual studies of shadow and light.
Some illustrations like *The Fountain of
Pirene* and *Circe's Palace* are mostly
engulfed in shadows with one fixed
distant light source. *Cadmus* and *Jason
and His Teacher*, on the other hand,
glow with brilliance as if lit by the

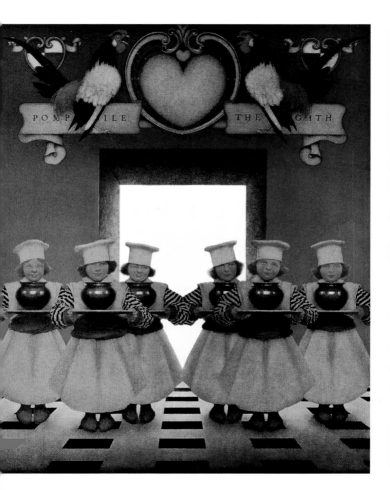

The Knave and Violetta
The Knave of Hearts
1925

bright rays of an orange setting sun.
In fact, warm hues like oranges and
yellows are placed beside dark shadowy
tones in many of the illustrations for this
book as well as for *The Arabian Nights*.

Parrish's greatest (and final)
book project came fifteen years later.
Parrish had done some paintings
called "Once Upon a Time." They sat
unused until Parrish discovered a play

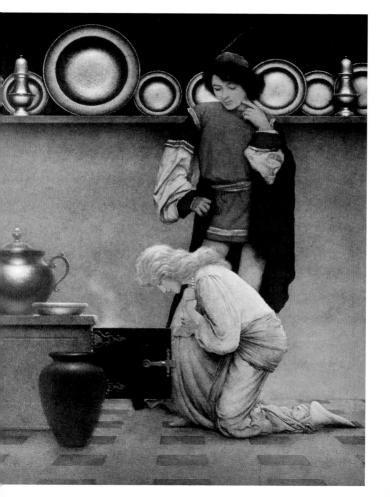

The Chancellor and King Pompdebile
The Knave of Hearts
1925

for children called "The Knave of Hearts." This was based, of course, on the nursery rhyme. Parrish was inspired by the dramatic content of the story and convinced his publisher to proceed with the project. *The Knave of Hearts* was released in 1925, resplendent with twenty-six beautiful color paintings. Besides the art, this was an over-the-top production featuring a

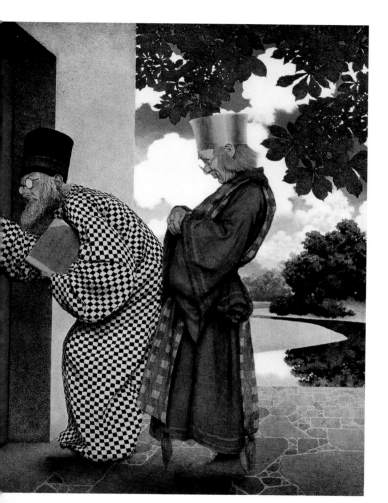

large-format book, its own box, and
high-quality reproductions on high-
grade paper. The publisher spared no
expense, and extensive publicity
aroused such interest that an exhibit
of original Parrish art was mounted in
New York, featuring the originals
from *The Knave of Hearts*.

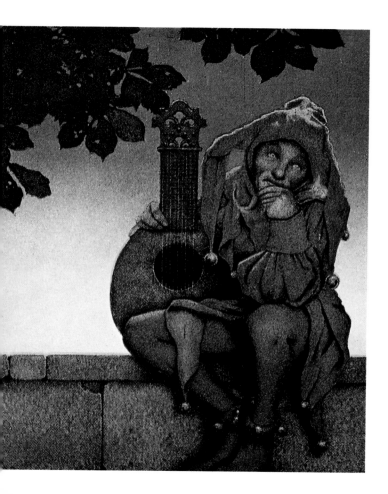

King, Chancellor and Pastry Cook
The Knave of Hearts
1925

No one can contest that these
illustrations represent some of
Parrish's best work – or at least that
which we most frequently associate
with Parrish. The highly stylized poses
of the figures, both symmetric and
not, and the fairy-tale landscape evoke
the play and its subject perfectly. The
theatrical element is also present in the

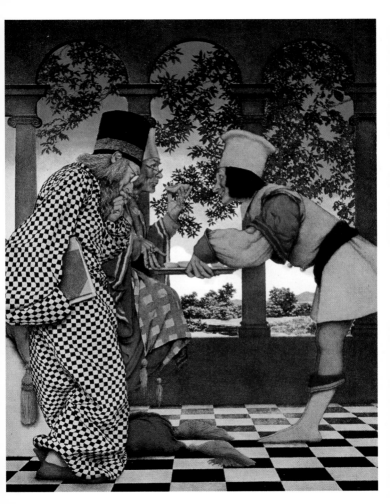

opening and closing illustrations of
The Manager, seen drawing the curtain
in the beginning and taking a bow
on the end page. Another illustration
in this book contains the famous *Chef
Between Two Lobsters* and *The Pastry
Cooks* with oversized spoons. Perhaps
even more important is the cover
lining painting called *Romance,*
depicting a breathtaking landscape of

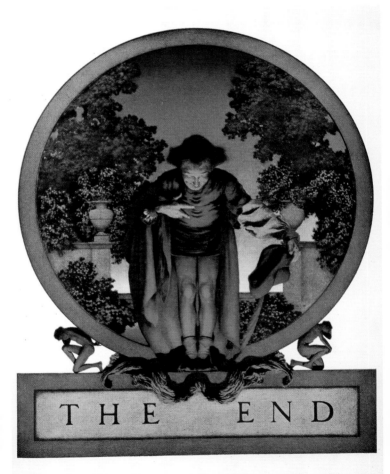

THE END

river, mountains, and castles. *Romance* became one of the many book and magazine illustrations by Parrish to enter the art print market in the 1920s.

Though the public acclaim for the artwork was overwhelming, sales of the book were mediocre. The high quality of the book dictated a ten dollar price tag – quite a lot for a children's book back then. Books

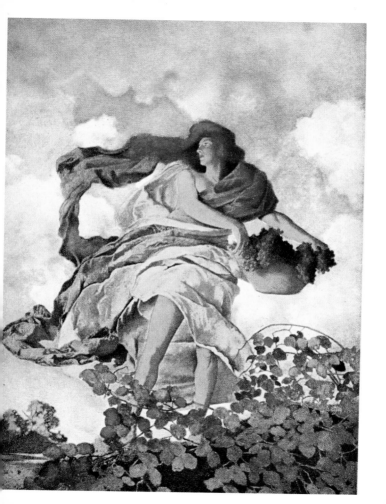

The Three Shepherds
The Golden Treasury of Songs and Lyrics
1911

printed in nonstandard book size are said to not sell as well and this was also the cause of the *Knave's* poor sales. Quite possibly, too, the beautiful illustrations were too complex and dramatic to appeal to a child. The low sales must have affected Parrish, who was used to more universal acceptance of his work.

By this time, Parrish was acquiring his fame and fortune from his art

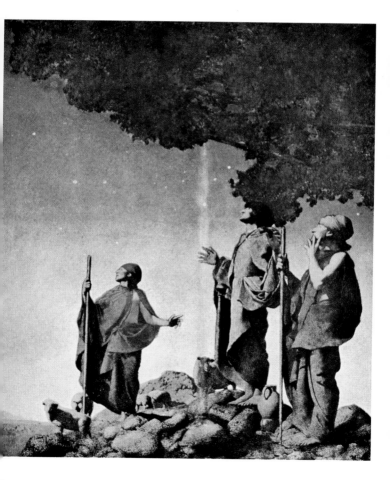

prints. Some were created for this market, while others were reprints from book and magazine illustrations.

Parrish eventually tired of the art print market as well, even though he controlled the subject matter. In 1930, Parrish left the world of commercial art – posters, ads, magazine, and book illustration – and went into semi-retirement. He entered one last agree-

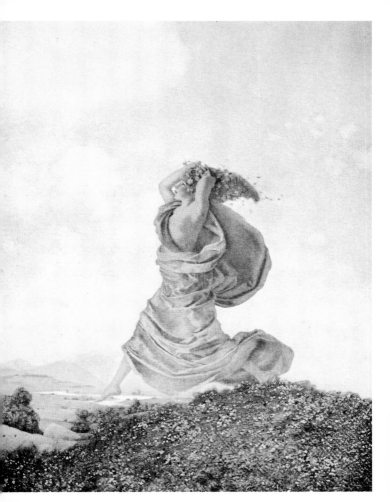

ment and submitted one painting a year to Brown & Bigelow, the famous calendar printing company. These paintings consisted of bucolic New England landscapes, without any hint of the fantastic and colorful book illustrations Maxfield Parrish contributed to the Golden Age of Illustration.

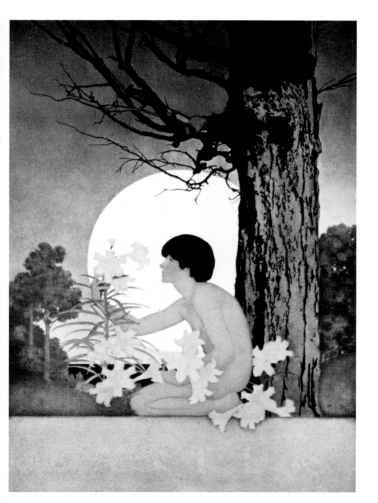

Vignettes